# Embedded Metaphor

Nina Felshin, Guest Curator

A traveling exhibition organized and circulated by

Independent Curators Incorporated, New York

*Itinerary*[*]

*John and Mabel Ringling Museum of Art*
Sarasota, Florida
21 September through 27 November 1996

*Dalhousie Art Gallery*
Dalhousie University
Halifax, Nova Scotia, Canada
March through April 1997

*Western Gallery*
Western Washington University
Bellingham, Washington
29 September through 22 November 1997

*Bowdoin College Museum of Art*
Brunswick, Maine
22 January through 16 March 1998

*Ezra and Cecile Zilkha Gallery*
Wesleyan University
Middletown, Connecticut
1 September through 2 November 1998

*as of September 1996

*Lenders to the Exhibition*

George Adams Gallery, New York

Perry Bard

Janet Biggs

Gavin Brown Enterprises, New York

James Casebere

Lynne Cohen

Caryl Davis

Bob Flanagan and Sheree Rose

Pat Hearn Gallery, New York

Oliver Herring

Sidney Janis Gallery, New York

Dale Kistemaker

Michael Klein Gallery, New York

Galerie Lelong, Paris

Donald Lipski

Mackenzie Art Gallery, University of Regina Collection

Antonio Martorell

Bill Maynes Contemporary Art, New York

Curtis Mitchell

Lorie Novak

P•P•O•W, New York

Max Protetch Gallery, New York

David Reed

Catherine Saalfield and Zoe Leonard

Robert J. Shiffler Collection

Michael and Barbara Smith

Carrie Mae Weems

## Acknowledgments

Nina Felshin is no stranger to ICI, having been both a founding member of ICI's Board of Trustees and a member of the ICI Exhibition Committee for many years. With this exhibition, *Embedded Metaphor*, she serves as an ICI guest curator for the fifth time.

ICI is especially grateful to the artists and lenders to the exhibition, without whose cooperation *Embedded Metaphor* and its tour could not have been realized. On behalf of Nina Felshin, I would like to extend special thanks to Marijo Dougherty Nora Eisenberg, Victoria Ellison, and Peter Huttinger, as well as René Blouin of the René Blouin Gallery.

Special acknowledgment goes to Susan Sollins, ICI's Executive Director Emerita, under whose aegis this exhibition was given its first breath of life and put into ICI's production schedule.

Each of ICI's exceptional staff—Judith Richards, Lyn Freeman, Jack Coyle, Alyssa Sachar, Heather Glenn Junker, Stephanie Spalding, and Linda Obser—have contributed particularly to the organization and success of this exhibition. Invaluable volunteer assistance has been provided by Jeanne Breitbart and interns Robert Trowe III and Eden Schulz. ICI's devoted Board of Trustees continues its committment to ICI's exhibition program unstintingly; I am especially grateful to each of them for their assistance and support.

Sandra Lang
*Executive Director*

# Embedded Metaphor

NINA FELSHIN

Sleeping and dreaming, conception and birth, lovemaking, illness, and finally death keep most of us in bed for much of our lives. As the staging ground for the life cycle, the bed is a psychologically charged piece of furniture that can evoke countless associations and complex feelings of fear, dread, desire, vulnerability, pain, passion, nurturing, and loss. It is a concrete representation, therefore, of intimacy, sexuality, and privacy. The bed is also a theater for dreaming, a launching pad for unconscious thoughts, and the place from which the child's imagination sets sail. Although beds have figured prominently in art of the past, in paintings by Jan van Eyck, Vincent van Gogh, Edouard Manet, and René Magritte, for instance, it is only since the 1980s that a significant number of artists have liberated the bed from its usual figurative context and examined it as an independent object. *Embedded Metaphor* examines the work of some of these artists, especially work in which the unoccupied bed becomes a forum for public statements about this most private space, thus engaging viewers in a ritual of reflection on cultural, political, and personal life.

This recent trend represents a major formal and conceptual departure from the tradition of Western narrative paintings of bedrooms that spans many centuries, including our own. In these paintings, the bed usually appears within the expected context of the bedroom and its inhabitant(s). As such, it functions as both formal and iconographical evidence that helps to locate and define the narrative content of the painting.

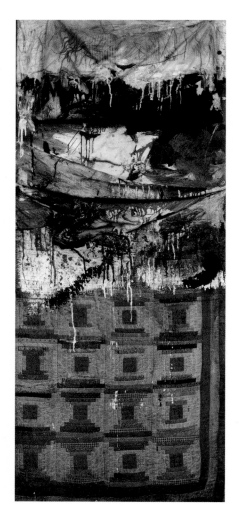

FIG. I

Robert Rauschenberg, *Bed*, 1955. Combine painting: oil and pencil on pillow, quilt, and sheet on wood supports, 6 feet 3¼ × 31½ × 8 inches (191.1 × 80 × 20 cm). The Museum of Modern Art, New York. Gift of Leo Castelli in honor of Alfred H. Barr, Jr. Photograph ©1996 The Museum of Modern Art, New York. ©1996 Robert Rauschenberg/Licensed by VAGA, New York, NY

Yet the current phenomenon in which the bed is abstracted from its familiar context is not without recent historical precedent. The best known example is the combine painting *Bed*, 1955 (fig. 1), by Robert Rauschenberg, who appropriated the pillow, sheet, and patchwork quilt from his own bed to serve as a pictorial surface when he was short of canvas. Jim Dine's construction, *Bedsprings*, 1960 (fig. 2), also incorporates found objects and, like other art of the time, uses urban refuse as both form and content. Rafael Montañez Ortiz's *Archaeological Find, 3*, 1961 (fig. 3), is one of several mattress destructions that allowed the artist to comment on, among other things, ritual processes of destruction, procreation, and creativity. Finally, Joseph Beuys's *The Abandoned Sleep of Me and My Loves*, 1965, and *Warmth Sculpture*, 1968, are part of a group of works that focus on the expressive potential of felt, one of the artist's signature materials. Although Beuys's works contain some anthropomorphic references, they primarily address the meaning inherent in the formal qualities of the materials which he uses. While several of these selected early examples might be nudged into the contemporary context of this exhibition, the more recent work included in *Embedded Metaphor* has been shaped by a set of impulses that gained momentum in the art world and "real world" of the 1980s. For many artists, the empty bed has come to symbolize the intersection of these aesthetic, cultural, and social impulses. The real point of convergence, however, is the body, whose absence from the bed only serves to indicate its strong presence in contemporary thought.

Since the 1980s, a growing number of artists have explored ways to evoke the human body without actually depicting it and, in its place, sometimes use objects and possessions that are closely associated with the body. The deliberate use of the vacant bed as a substitute for the body has allowed the artists in this exhibition to make work that embraces representation and recognizable imagery, yet at the same time comments on absence. While the empty bed can signal the possibility of loss, loneliness, and even death, it can also suggest that it is not the individual physical body that is in question, but rather our ideas about the social or psychological construction of the human subject. The decontextualized bed, therefore, serves as a reflection of cultural values and as a repository of collective experience, rather than simply as a site of personal narrative.

In the 1980s, cultural expression became highly politicized, and artists began to focus on issues such as abortion, the AIDS crisis, and sexual orientation. Our

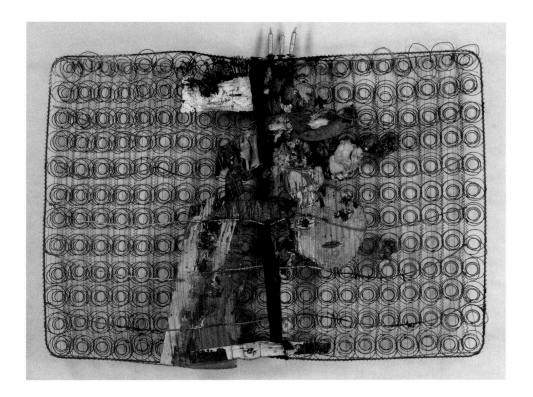

FIG. 2

Jim Dine, *Bedsprings*, 1960. The Solomon R. Guggenheim Museum, New York

bodies, to paraphrase Barbara Kruger, had become battlegrounds. Artists joined the morality debate in opposition to attempts by the church and state to restrict personal and artistic freedom of expression. By the end of the 1980s, contemporary art had become ground zero for many of the political and religious Right's attacks on expressions of sexuality. It is not surprising that the bed—a quintessential symbol of intimacy, sexuality, and privacy—became an object of expressive potential for many artists, through which they could present their responses to repression in its many guises.

One of the most explicit responses to the increasingly repressive artistic climate that climaxed in the 1989 controversies surrounding Robert Mapplethorpe and Andres Serrano is *Keep Your Laws Off My Body*, 1989, an installation by Catherine Saalfield and Zoe Leonard. The installation consists of two main components: a videotape and a bed with silkscreened sheets. The sheets are imprinted with text excerpted from repressive legislation, including attempts to curtail reproductive rights and the various Helms amendments, which have called for the criminalization of sodomy, an end to federally funded AIDS education, and the withdrawal of

FIG. 3
Rafael Montañez Ortiz, *Archeological Find, 3,*
1961. Burnt mattress, 6 feet 2⅞ × 41¼ × 9⅜
inches (190 × 104.5 × 23.7 cm). The
Museum of Modern Art, New York. Gift
of Constance Kane. Photograph ©1996
The Museum of Modern Art, New York

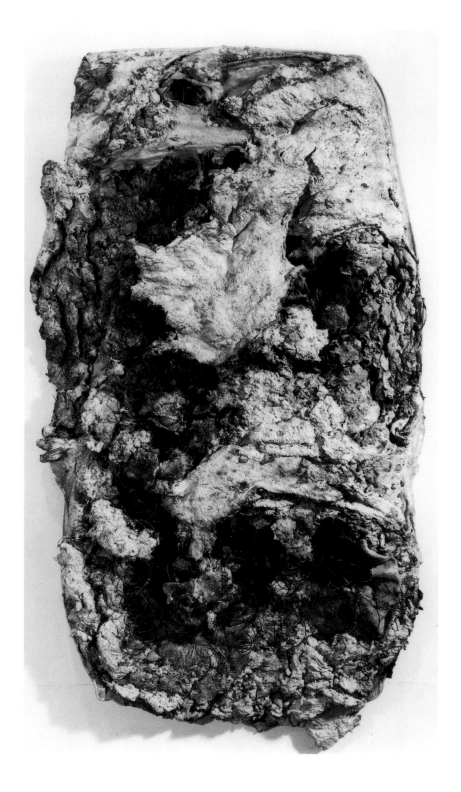

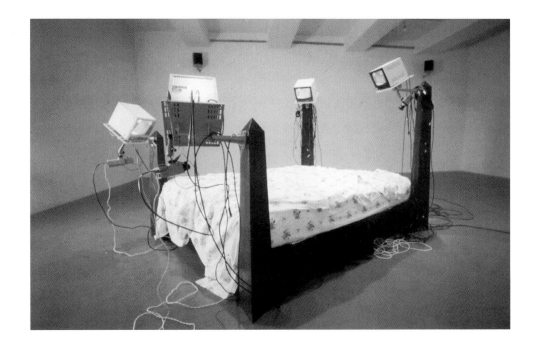

FIG. 4

Julia Scher, *Always There*, 1994. Mattress, bed frame, sheets, video and audio equipment, approximately 70½ × 70 × 103 inches. Courtesy Andrea Rosen Gallery, New York

NEA support for art deemed obscene. The videotape intercuts footage of police in riot gear violently confronting demonstrators from the AIDS activist group ACT UP in front of New York's City Hall with sensuous images of a lesbian couple (the filmmakers, Saalfield and Leonard) in bed together and engaged in domestic activities. The discordant soundtrack, which intersperses self-referential sounds of a whirring movie projector, with the occasional "ever-so-symbolic siren,"[1] further underscores the erosion of boundaries between the private and public realms that is a central theme of this work.

Another work that examines the shifting border between private and public space is Caryl Davis's *Conspire*, 1990. This smaller-than-life-size bed, flanked on either side by mock prayer benches, humorously conflates the sacrament of marriage with our culture's worship of sex. The positioning of the benches next to the bed also implies supervision and surveillance. By departing from the standard bed size—it is shorter than it is wide—the bed comments on attempts by organized religion to dictate morality and deny the right of individuals to either accept or deviate from its rigid doctrines.

A visually explicit reference to the surveillance of personal space is found in Julia Scher's interactive installation, *Always There*, 1994 (fig. 4), which is dominated

by a four-poster bed. Attached to each of the obelisk-shaped bedposts are downward-angled video monitors. Below each monitor is a surveillance camera aimed at the mattress below, which visitors are encouraged to use. Any activity is recorded by the cameras and is instantly replayed on the monitors. Speakers mounted in the corners of the room in which the work is installed play the song "Always There." In this context, the song's title and intimate lyrics acquire an ironic twist.

Mel Chin's *Jilava Prison Bed*, 1982, addresses the state's attempt at controlling free expression. The work is dedicated to a Romanian Orthodox priest who was imprisoned in the early 1980s for his outspoken views in opposition to atheism, then the official ideology of Romania. Chin's commemorative bed assumes the shape of a cross—its headboard resembles prison bars and its mattress is perforated by steel spikes to suggest a crucifixion, in this case of a political prisoner.

The unoccupied bed, as suggested by Chin's work, can also be a metaphor for confinement. It is the most basic, if not the sole, furnishing of the prison and monastic cell, and the hospital room. In two of James Casebere's photographs, *Asylum*, 1995, and *A Barrel Vaulted Room*, 1995, the only object in sight is an austere bed. The barred windows and windowless rooms seen in Casebere's photos of fabricated interiors can suggest confinement, whether it be a voluntary retreat or an involuntary internment.

Bob Flanagan's and Sheree Rose's *Gurney of Nails*, 1992, is a hospital gurney transformed into a bed of 1,400 nails. Flanagan, who died January 4, 1996 at the age of 43, was one of the oldest living survivors of cystic fibrosis and a self-avowed masochist who "learned to fight sickness with sickness."[2] Although Flanagan was frequently confined to a hospital bed, he attributed his prolonged survival to the masochism that shaped his life and his art. *Gurney of Nails* makes a connection between his masochistic behavior and his illness and, like Mel Chin's *Jilava Prison Bed*, also evokes a crucifixion.

Personal and cultural issues also underlie the work of artists who examine childhood through the empty bed. The similarity between cribs and prison cells—most chillingly apparent in the stainless steel bars of hospital cribs—has been exploited by some artists to explore the underbelly of childhood and to suggest vulnerability, fear, disturbance, and dysfunction. Distortion often heightens the psychological potency of the work in the exhibition, alerting the viewer to concerns about deviation from an idealized norm. In Janet Biggs's installation *Crib,*

1993, the abnormally high legs of the crib and the toy horses encircling it like sentries suggest some babies might be better off protectively confined and out of reach of the adults upon whom they must depend.

The foreboding quality of Mona Hatoum's crib sculptures is caused by their uninviting materials, and exaggerated, disproportionate scale—they are taller, but otherwise smaller than the standard size. The sharp wires strung lengthwise across the bottom of Hatoum's steel crib, *Incommunicado*, 1993, resemble a menacing egg slicer rather than a mattress support. With a title that suggests isolation, an appearance that is extremely sinister, and a scale that intensifies the confining nature of cribs, *Incommunicado* connotes imprisonment and torture, a theme that underlies other works by this Palestinian-born artist. *Silence*, 1995 (fig. 5), constructed in the same scale as the preceding work, is an exceedingly fragile, clear glass baby crib. In a highly successful union of form and material, *Silence* communicates a very direct, yet poetic, sense of vulnerability. Hatoum's ethnic ties to the violent history and politics of Palestine suggest a reading of her crib sculptures that extends beyond their relation to the nursery, to comment on the fragility of life in a country where one must continually fight to survive amidst violence.

Under the foot of Ann Messner's diminutive cast iron *Bed*, 1993, is a megaphone partly concealed by a dark gray felt blanket draped over the lower half of the bed. Despite its small size, Messner's *Bed* projects a sinister quality that connotes fear. As the artist points out, in order for an adult to fit into this bed, he or she would have to assume the fetal position, a posture which suggests vulnerability, fear, and the need to be protected. Children (and some adults) sometimes imagine terrifying things lurking beneath the bed and often refrain from dangling their legs within reach of these imagined horrors. The partly hidden megaphone can operate metaphorically as a child's cry for help, or as a device to amplify and give voice to the unconscious, which symbolically inhabits this dark and hidden place. Messner's *Bed* suggests that for children and adults alike, the bed represents the intersection of the known and unknown, the conscious and unconscious.

Unlike the often frightening reality of childhood, in literature children's beds are often presented as places of comfort and symbols of an innocent and protected childhood. As in Clement Moore's "The Night Before Christmas," Robert Louis Stevenson's "The Land of Counterpane" and "My Bed is a Boat," and Sylvia Plath's *The Bed Book*, poetry repeatedly casts the bed as the place where pleas-

FIG. 5

Mona Hatoum, *Silence*, 1994. Glass in 5 pieces, 50 × 36½ × 23¼ inches. Courtesy Alexander and Bonin, New York

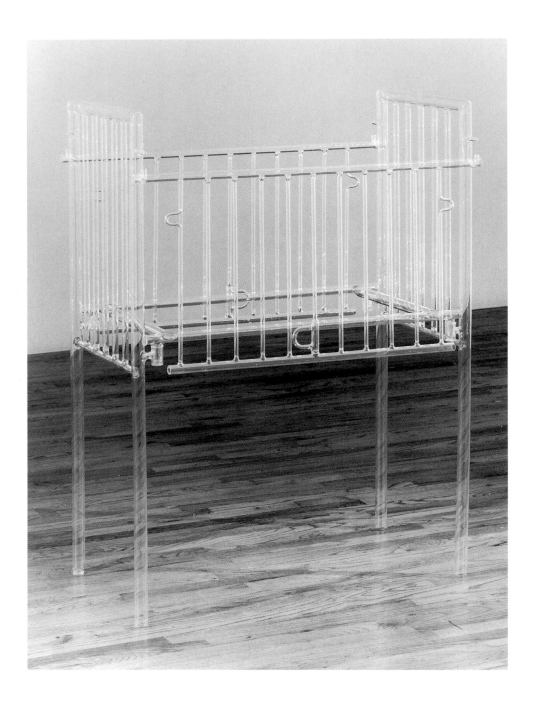

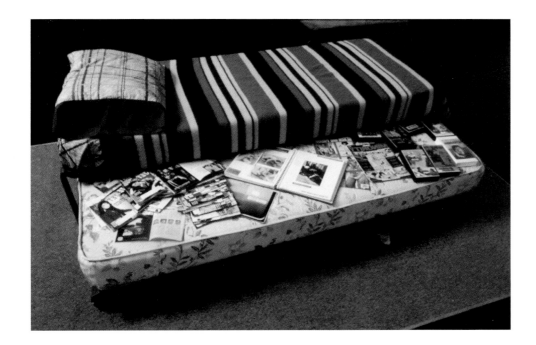

FIG. 6
Glenn Ligon, *Twin*, 1995. Mixed media,
28 × 72 × 106 inches. Courtesy Max
Protetch Gallery, New York

ant and distracting dreams and fantasies are enacted. But just as frequently—
"Rock-A-Bye-Baby," "The Princess and the Pea," and "Little Red Riding Hood"
come to mind—the bed has an anxious presence that suggests a side of childhood
where fear, cruelty, and violence are possible. Clearly, the artists above align them-
selves with the latter point of view.

For several other artists, the empty bed is an arena in which to consider how
gender and cultural identity are shaped by societal norms. Like the previous artists,
their vision remains unclouded by rosy perceptions of childhood. In Glenn Ligon's
*Twin*, 1995 (fig. 6), a trundle bed serves as a metaphor for growing up gay in an
African American middle-class milieu. The trundle bed symbolizes Ligon's twice
stigmatized identity and the need to conceal it in the face of societal pressure.
Strewn across one end of the partially pulled-out lower mattress are gay porno-
graphic magazines and tapes depicting both African American and interracial gay
couplings. The other end of the mattress is littered with copies of *Jet* magazine "to
imply normalcy."[3] The upper mattress is made up with sheets, a pillowcase, and a
blanket. The brown, yellow, and black stripes of the blanket recall prison bars and
thus suggest the double isolation of gay and lesbian members of minorities, who
experience both racial, ethnic, and sexual prejudices from so-called "mainstream"

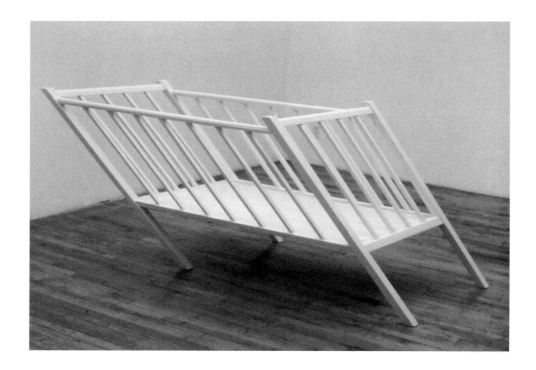

American culture and are further ostracized within their own cultures due to their
sexual orientation.

While the primary text of Robert Gober's crib sculptures deals with the dark
side of childhood, homosexuality also operates as a subtext in his work. The per-
ilously slanted side rails of his *Pitched Crib*, 1987 (fig. 7), recall the nursery rhyme
"Rock-A-Bye-Baby." Gober's work speaks of imminent danger and a childhood
that deviates from the norm, possibly making reference to the belief that homosex-
uality is biologically based. In *X-Crib*, 1987, Gober has reconfigured the standard
rectangular crib by constructing intersecting side rails that would prevent move-
ment of any kind. Art critic Gary Indiana described *X-Crib* and an X-shaped
playpen that the artist exhibited together as "double triangular training jails for
twins or schizophrenic children."[4] Like *Pitched Crib*, Gober's *X-Crib* also suggests
deviation from a norm.

Dale Kistemaker's installation *His Bedroom*, 1994, which features a simple, ply-
wood twin bed made up with one white sheet and a cement pillow, deals with 1950s

notions of masculinity and how they shaped the identity of boys growing up in postwar America. The impersonal pronoun used in the work's title suggests a generic meaning, although the artist has obviously drawn on personal experience. Projected onto the bed, the primary focus of the installation, are portions of Kistemaker's grade school report cards. One of them offers an inventory of desirable work habits: "Works well by himself, works in a neat and orderly manner, follows directions," etc. Slides of Kistemaker's childhood drawings, including images of a rocket ship and of a bomb target, are projected onto the bed. Projected onto the walls are images of Plasticville, a plastic model town created by the young Kistemaker that manifests the aggressive vision of American progress and prosperity prevalent in the 1950s.

Elaine Reichek's *A Postcolonial Kinderhood*, 1994, also incorporates a bed (along with other bedroom furnishings) as the centerpiece of an installation that investigates how a child's identity, in this case his or her religious identity, is shaped by cultural values and social conventions. The work in this exhibition, Reichek's childhood bed and nine samplers embroidered by the artist, is a selection of objects from her original installation. In recreating the childhood bedroom of her parents' ersatz Americana-filled Dutch colonial home in Brooklyn, Reichek specifically addresses her family's attempt to assimilate and mask its Jewishness. Generally speaking, the installation examines the dilemma many immigrants face as they redefine themselves in an alien culture. Like other works in this exhibition, Reichek's Ethan Allen "1776 Collection" bed is intentionally altered. Scaling down the size of the bed by several inches so that it appears slightly off kilter subtly suggests that something is awry—that outward signs of conventional domesticity can conceal an underlying anxiety about one's background and difference. Embroidered on the head- and footboard of the four-poster bed are the words of two former United States presidents: at the head, George Washington's welcome to "the children of the stock of Abraham" and at the foot Richard Nixon's question, "Aren't the Chicago Seven all Jews?" The bedspread displays the Yiddish expression (also embroidered), *"Was willst du von meinem Leben?"* (What do you want from my life?), which sums up Reichek's sense of being "trapped in the middle."[5] The colonial-style braided oval rug on which the bed rests underscores the notion of sweeping one's background under the rug. Although the samplers mimic authentic colonial patterns, their troubled texts are a far cry from the comforting adages

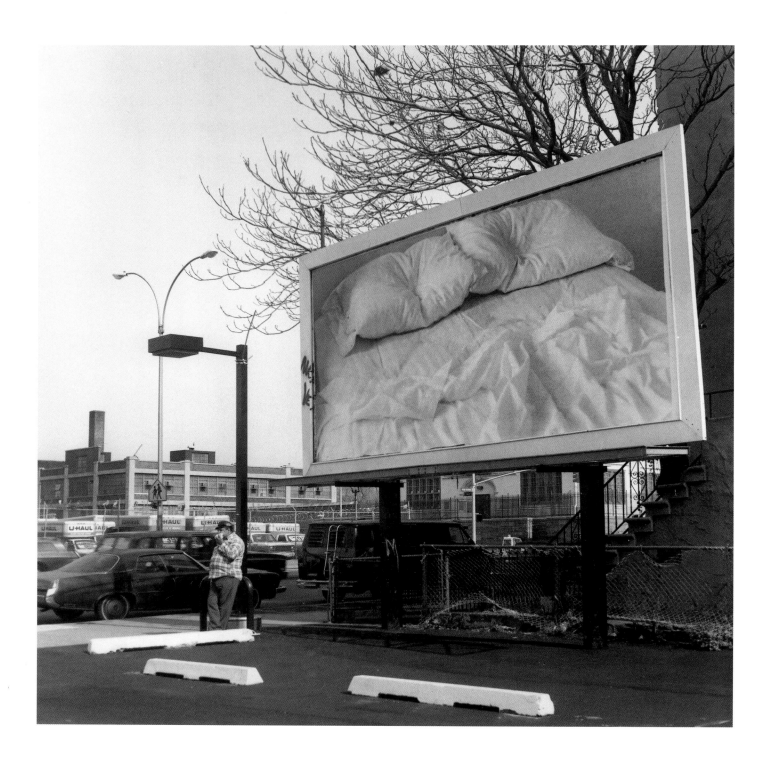

favored in colonial times. A particularly disturbing one reads: "I used to fall asleep every night thinking of places to hide when the SS came. I never thought this was the least bit strange." One critic observes that Reichek's nightmarish bedtime fantasy is her "personal 'Land of Counterpane'. . . , the world of imaginings created by children in bed," where "sheets covering knees become mountains, flashlights under blankets become caves, sounds on the roof become intruders."[6]

In the context of the AIDS crisis, the bed has proven itself to be a powerful metaphor for the public dimension of private experience. Since the early 1980s, AIDS has had an enormous political, personal, and aesthetic impact on the art world. The crisis fostered a sense of community and commitment that encouraged many gay and lesbian artists to openly address their sexual identity. For others— both homosexual and heterosexual—keeping vigil around hospital beds became an all-too-frequent activity. The pervasive sense of loss and death brought about by the AIDS crisis has hovered over the art world for well over a decade now, and the bed, which was "once a site of private pleasure, has been transformed into a memorial, a site of public pain."[7] AIDS has caused private suffering, loss, and grief. In the public arena, the response of both church and state to the crisis has led to more visibly charged forms of homophobia and increased attempts to limit rights of privacy. The AIDS crisis, therefore, provides an outstanding paradigm for the intersection of private and public boundaries. The empty bed provides an equally potent metaphor.

Among the artists who have addressed the AIDS epidemic through the symbolism of the bed is Felix Gonzalez-Torres, who died of AIDS on January 9, 1996. In 1991, shortly after the death of his lover from AIDS, Gonzalez-Torres created a billboard-size photographic image of an empty double bed (fig. 8), its pillows and sheets tellingly imprinted by the bodies of a now absent couple. With the artist's recent death, the image now seems hauntingly prophetic. Although much critical writing about Gonzalez-Torres has focused on AIDS, the artist himself preferred that the meaning of his work remain ambiguous and left open to interpretation. The gender, sexual orientation, and state of health of the bed's former occupants are not known or suggested, inviting viewers to project their own associations and memories onto the bare, rumpled sheets. Installed as an outdoor billboard, the image takes on additional meaning from its public context, underscoring the differences between public and private spaces.

FIG. 8
Felix Gonzalez-Torres, *Untitled*, 1991. Billboard. Size varies with installation. As installed for The Museum of Modern Art, New York, "Projects 34: Felix Gonazalez Torres," May 15–June 30, 1992. Courtesy Andrea Rosen Gallery. Collection The Museum of Modern Art, New York.

Oliver Herring uses a mattress-like bed (often in combination with clothing abstracted from the human body) as a vehicle to explore his relationship to AIDS. *Castle*, 1994, is part of his ongoing project, *A Flower for Ethyl Eichelberger*, a series of works made from hand-knitted Mylar and dedicated to the well-known 1980s performance artist who performed in drag and committed suicide after being diagnosed with AIDS. The process of knitting with Mylar is seen by Herring as a "personal form of AIDS activism," as was the use of clothing in Eichelberger's performances. It is, according to the artist, "both a personal meditation on the death of an admired artist and a metaphor for AIDS in general."[8] His floor-bound pieces, such as *Castle*, are inspired by the NAMES Project AIDS Memorial Quilt, which has usually been installed on the floor or ground, the "most logical plane," observes Herring, "to deal with mortality."[9] While Gonzalez-Torres's bed, with its sunken pillows and creased sheets, can suggest a departure or death, Herring achieves a similar result with his airy sleeping mat by layering a series of knitted "blankets" (some with subtly varied coat-shaped cutouts) one upon the other, to create a hollow that suggests the removal or absence of human presence.

Another pressing social issue that artists began to address in the 1980s through the use of the empty bed is homelessness. Bed equivalents—sleeping bags, sidewalk gratings, benches, cardboard shelters, and sidewalks—are makeshift sleeping quarters for the nomadic urban homeless and an ubiquitous presence for city dwellers. Perry Bard's installation *Shelters and Other Spaces*, 1990, includes two bed equivalents. One, *Shelter and Text from an Interview*, 1989, a cardboard shelter, bought from a homeless man who had been sleeping in a lower Manhattan park for three years, is accompanied by a text excerpted from an interview with him, in which he recounts how the daily removal of his shelter by park service employees forced him to rebuild a new one each day. The other, *Here Lies*, 1989–90, is a bed and/or grave made of cinder blocks, urban rubble, glass, and a mirror. Like the cardboard shelter, this construction also resembles a coffin, suggesting the untimely fate of many homeless people. Slides of makeshift shelters documented by Bard over a three-year period are projected onto the glass pillow of *Here Lies*, including an image of a shelter made of chenille—a fabric associated with colonial-style bedspreads—draped over a box. In this exhibition, Bard presents eight photographs of homeless shelters selected from the projected images of *Here Lies*.

Another work that refers to homelessness is Curtis Mitchell's *Untitled (Sidewalk grating)*, 1990. The human form is evoked by the size of the work, approximately that of a single bed. The configuration of metal bars suggests the undercarriage of a bed. In freezing temperatures, sidewalk gratings over steam-emitting vents often serve as beds for the homeless. Mitchell's grating, embedded with glittering, multicolored crushed glass and reconstituted dirt, ironically calls attention to its aesthetic status as an art object.

A different kind of homelessness is addressed in Antonio Martorell's installation *Kamikaze*, 1991. The title puns on the name for the World War II Japanese pilots who conducted suicide missions against American warships and likens it to the sound of the Spanish words for bed *(cama)* and house *(casa)*. Thoughts of these wildly reckless fighter pilots preoccupied the young Martorell during the early years of World War II. *Kamikaze* draws on childhood memories of a "most beloved shelter" in which his family lived following an eviction from their home in Santurce, Puerto Rico.[10] The cocoon-like enclosure, constructed of several mattresses with a canopy of tulle mosquito netting, was the embodiment of security, comfort, and cozy domesticity for the five-year old boy, just the opposite of a young child's threatening fantasies about kamikazes. As El Museo del Barrio Director, Susana Torruella Leval has observed, this installation of canopied mattresses is really about collective memory, "the homes we lost, the homes we remember, the homes we can reclaim, and the homes we are always moving toward."[11]

For many artists, the bed offers an arena in which to present their feelings and ideas about personal, political, and cultural issues and the ways in which they intersect. Despite the highly charged subject matter of these works, polemics give way to poetry in objects, installations, and photographic representations that give free reign to the viewer's imagination, memory, and associations. Even when such sociopolitical issues do not form the overt content of the work, the social and political context from which the vacant bed has emerged cannot be ignored as a partial explanation for artists' increasingly conspicuous interest since the 1980s in the bed's metaphoric potential. The undercurrent of anxiety that runs through most of this work recalls Anthony Burgess's observation, "The study of sleep is wonder; the study of beds is fear."[12]

Notes

1   Catherine Saalfield and Zoe Leonard, unpublished artists' statement.

2   Artist's quote in Andrea Juno and V. Vale, *Bob Flanagan: Supermasochist* (San Francisco: RE/Search People Series, vol. 1, 1993), p. 3.

3   Roberta Smith, "Glenn Ligon," [Art in Review], *New York Times*, 3 November 1995.

4   Gary Indiana, "A Torture Garden," *Village Voice*, 27 October 1987, p. 105.

5   Suzanne Slesin, "Perils of a Nice Jewish Girl in a Colonial Bedroom," *New York Times*, 17 February 1994.

6   Robert Mahoney, "Elaine Reichek: Assimilation in America," *Fiberarts* (September/October 1984), p. 61; "The Land of Counterpane" refers to a poem of the same name by Robert Louis Stevenson.

7   Dena Shottenkirk, "Felix Gonzalez-Torres at MoMA Projects Room," *Art in America* 80 (November 1992), p. 132.

8   Artist's statement for "Pulp Fashion," an event organized by Dieu Donné papermill and curated by the author and Elise Siegel, November 1995.

9   Oliver Herring, in a televised interview about the exhibition *Empty Dress: Clothing as Surrogate in Recent Art,* curated by the author. "State of the Arts," NJN TV, 16 November 1995.

10  Susana Torruella Leval, "Houses," in the exhibition catalogue *A House for Us All* (New York: El Museo del Barrio, 1992), p. 11.

11  Ibid, p. 7.

12  Anthony Burgess, *On Going to Bed* (New York: Abbeville, 1982), p. 95.

*Plates*

*Perry Bard*

My artwork is about discomfort. Physical and intellectual.
Mine and others.

The extremes of comfort and torture have become increasingly
visible on city streets. Our post-industrial landscape has created
a subculture of hunters and gatherers—urban dwellers whose
daily existence consists of constructing a shelter for the night.

These photographs address the tension—between cardboard
and concrete. Comfort and torture. Rich and poor. Art and life.

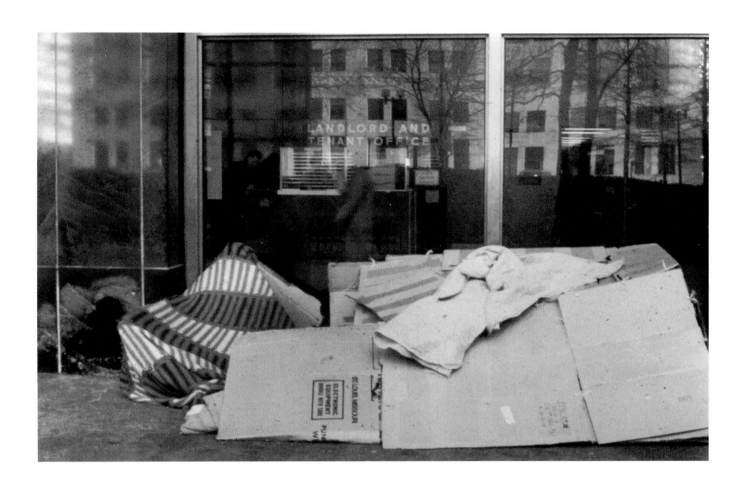

*Shelter, 111 Centre Street, New York City*, November 1989. Cibachrome print, 16 × 20 inches

*Janet Biggs*

My bed was a huge castle with a moat of fiery, snorting horses, each one ready to protect me from lurking danger.

Her bed was a precarious thing, barely balanced on stilts, ready to fall at any moment. Surrounding the bed was an obstacle course planted to foil any rescue attempt. She was always out of my view, out of my protection.

Memory is a construct that employs a past event, mediated by perspective and a myriad of outside influences.

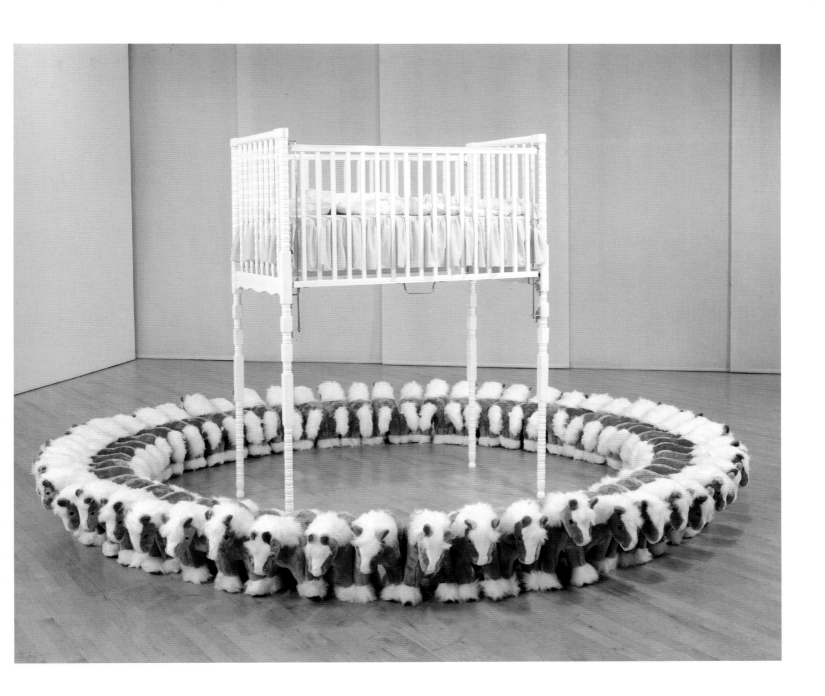

*Crib*, 1993. Installation: wood, cotton, and stuffed toys, 76h × 132 inches in diameter

*James Casebere*     This particular image is about isolation and draws attention to the relationship between religious and solitary confinement in the United States. Our contemporary notion of incarceration reflects, in part, 19th century Quaker ideas that connected contemplative reflection with reform and redemption. Today, however, solitary confinement, which began as a progressive reform supported by the belief that behavior can be changed through meditation and a dialogue with God, retains merely an historical relationship with its Quaker origins.

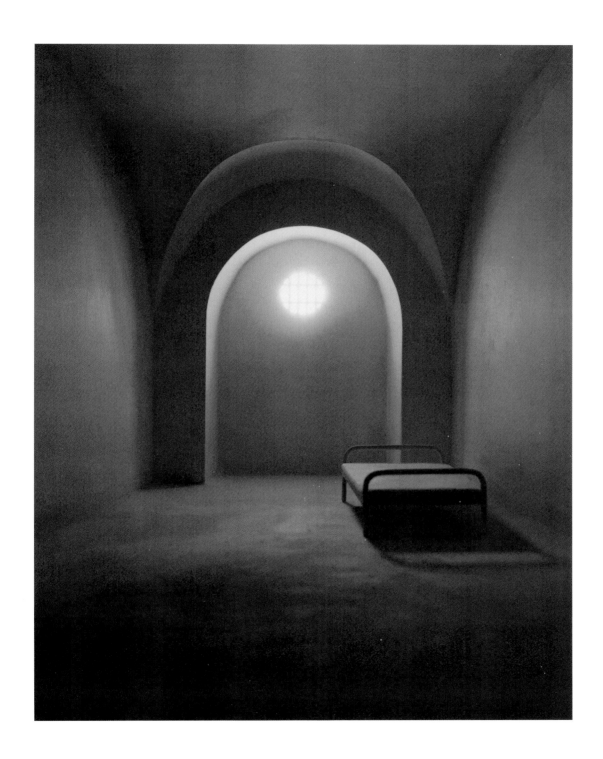

*A Barrel Vaulted Room*, 1994–95. Cibachrome print, 60 × 48 inches

## Mel Chin

In 1982, while living in Houston, Texas, Chin was invited to participate in an exhibition to raise funds for Amnesty International. For this exhibition, artists were given, at random, case studies of political prisoners from around the world. Chin's subject was Father Calciu-Dumitreasa, a Romanian Orthodox priest who was arrested as a result of his public criticism of atheism, which was the official ideology of the Romanian state. At the time Chin made *Jilava Prison Bed for Father Gheorghe Calciu-Dumitreasa*, 1982. Father Calciu-Dumitreasa was reportedly on a hunger strike to protest his involuntary treatment with drugs, abuse from prison guards, and pressure from Romanian officials to request a pardon that would have been considered an admission of guilt. Thus, as a means of calling attention to the inhumanity of the situation, Chin fabricated a cross-shaped bed with prison bars for a headboard and steel spikes penetrating the mattress. Although visually alluring, Chin's sculptures are charged with symbols of conscience. As he has stated in the past, "It doesn't suffice for me just to make beautiful objects . . . The sculpture must be loaded with information. Its beauty acts like a Venus Flytrap; it's a visual, aesthetic, and conceptual snare. I think that you have to use a lure to get the message across, and that there should always be a disturbing or precarious edge to that message."

David S. Rubin. From the exhibition catalogue, *Cruciformed: Images of the Cross Since 1980*. Cleveland Center for Contemporary Art, 1991.

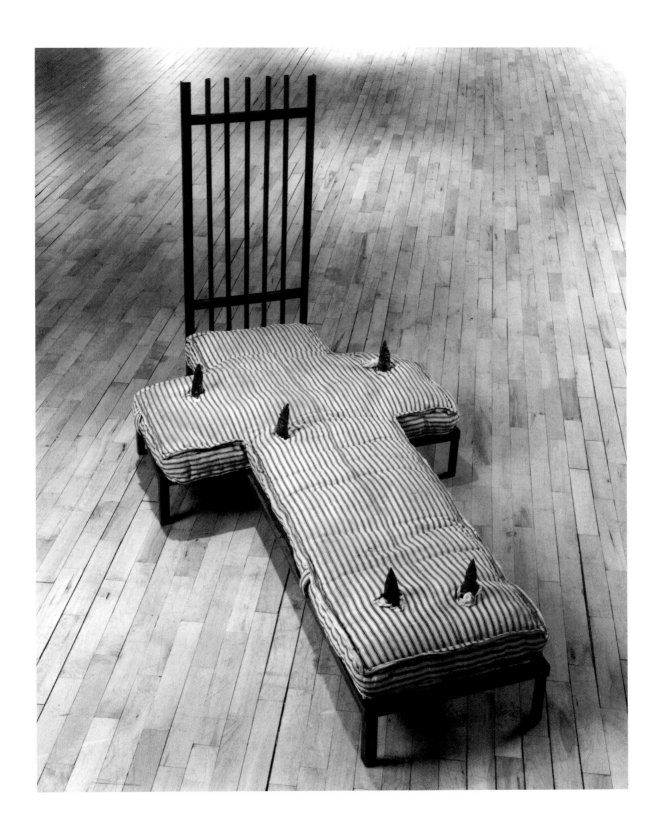

*Jilava Prison Bed*, 1982. Steel and cotton, irregular: approximately 42 × 37 × 69 inches

*Lynne Cohen*

For a long time I have been preoccupied by deceptions and illusions, by how things are not quite what they seem to be. I am intrigued by how much murals of "exotic" places never quite convince us or take us there, how resorts simulate mental hospitals, how mental hospitals resemble retirement homes, how boundaries often turn out to be merely conceptual, how weapons look like toys, how the so-called fraternal frequently conceals contempt, and how are our hopes and dreams are far more flimsy than we would like to imagine. I am fascinated by art and camouflage and the way in which life imitates art. I am struck by the many references and allusions in the "real" world to episodes in art history—to the niches and altars of gothic architecture, to neo-classical frescoes, to renaissance perspective, to genre painting, to the dimensionality of baroque painting, to Vermeer's ability to bestow a "devotional" aura on quite secular subjects, to the work of conceptual and language art, to minimalist objects, to pop art, to the readymades of Marcel Duchamp, to Joseph Kosuth's clocks, to Dan Flavin's lights, to Gerhard Richter's "Mens Clubs," to Joseph Beuys's blackboards, to installations by Guillaume Bijl, and to Richard Artschwager's Formica, Naugahyde and wood paneling, and so on.

Excerpt from a 1995 lecture by the artist

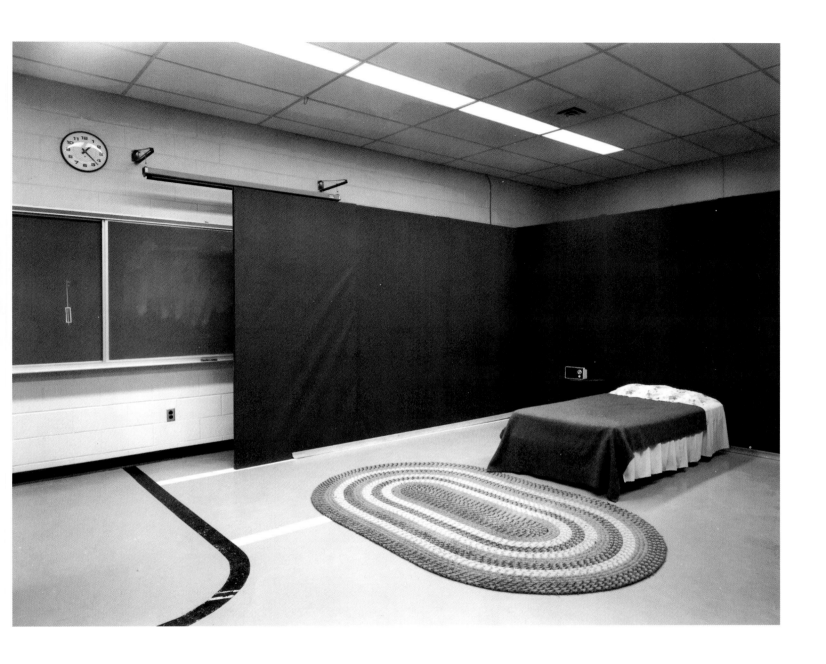

*Classroom*, n.d. Gelatin silver print with text on mat, 43¾ × 50½ inches (framed)

Caryl Davis

*Conspire* was an attempt to create a plausible, yet honest, comment on the public identity of marriage. . . . replete with kneeling benches to ascend or descend, from which to reflect on this "holy assembly" (or conspiracy) of the traditional matrimonial bed. Somewhat to my surprise, this seemingly formidable fortress ended up looking and feeling more like a raft cut loose at sea. . . , perhaps claustrophobic, yet strangely comforting in the exclusiveness of its sequestered domestic intimacy. Admittedly, it suggested a pleasurable reversal and a more expansive view of the "conspiracy" than I had originally imagined.

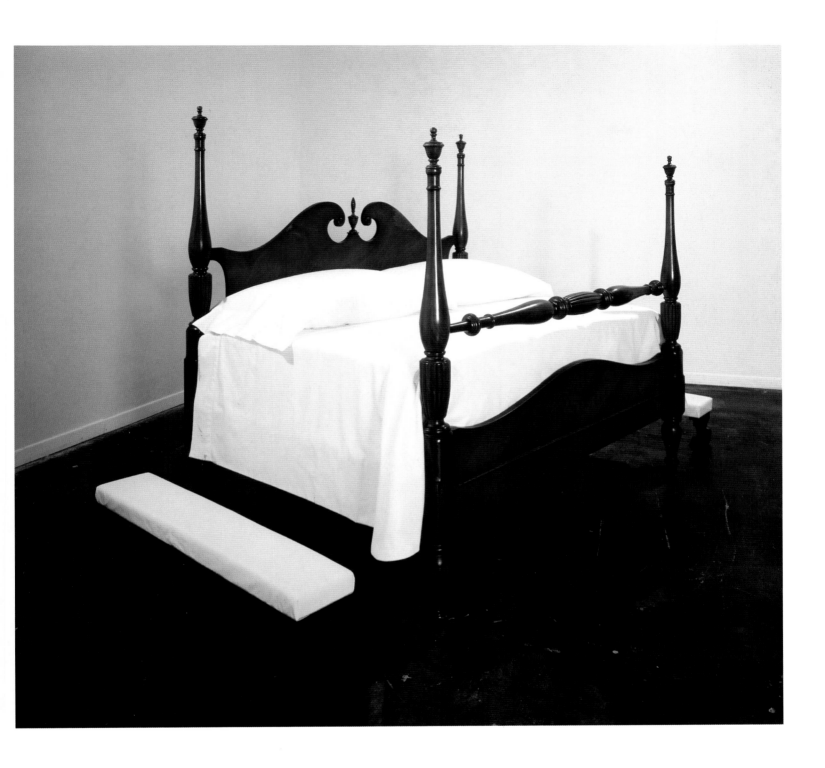

*Conspire*, 1990. Bed, linens, pillows, and prayer benches, 56 × 44 × 74 inches overall

*Bob Flanagan*

*and Sheree Rose*

*The Gurney of Nails* was part of the *Visiting Hours* installation mounted at the Santa Monica Museum of Art in 1992.

The theme of *Visiting Hours* was the juxtaposition and conjoining of Bob's life-long obsessions: Cystic Fibrosis (his genetic illness) and sadomasochism (his sexual identity). CF and SM were dualistic demons forever warring over control of his body.

When Bob first mentioned that he was going to lie in his hospital bed and engage the museum-going public every day that the show was open, I was impressed by his commitment to his vision. I came up with the idea of making the hospital bed an actual bed of nails, as Indian fakirs do, thus upping the ante in the quest for excruciating ecstasy mingled with artistic integrity. Bob took the concept in, swallowed it whole, then looked at me and said, "How about a gurney of nails?" Thus, fourteen hundred nails later, each one hand-hammered, the *Gurney of Nails* was wrought: a startling icon, arousing everyone's fear of hospitalization (and death) as well as conjuring up exotic images of foreign mysticism combined with sadomasochistic practices that the viewer could only fantasize about; wondering how it must feel to lie there, vulnerable to the worst that man and God could inflict, all the while becoming more and more sexually aroused.

In the meantime, Bob Flanagan, Supermasochist, King of the Sick, lay quite comfortably in his hospital bed, eating muffins, conversing with mere mortals, giving them a rare opportunity to share in this twisted Oz of our own design.

Sheree Rose, June 1996

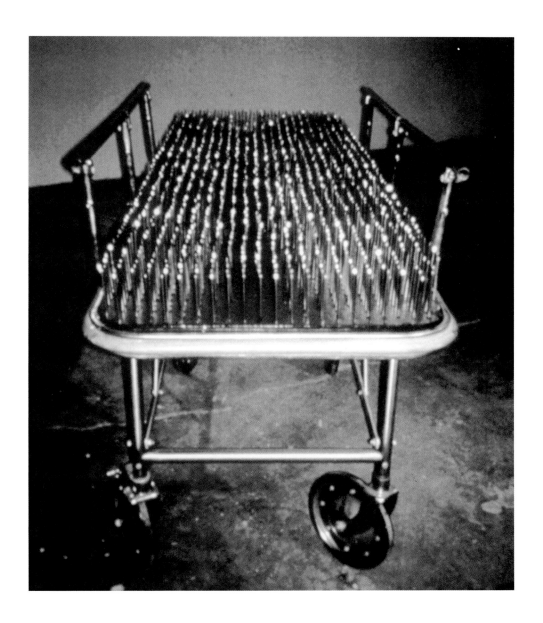

*Gurney of Nails,* 1992. Hospital gurney and 1,400 nails, 37 × 27 × 71 inches

*Renée Green*

The story of this work begins in a ramshackle antique shop in upstate New York. Or perhaps it goes back even farther, to childhood and memories of French Provincial furniture displays in department stores. At any rate I found a bolt of toile fabric with depictions of pastoral scenes from a past Europe which I took with me to France as a kind of talisman.

From a Frenchman I'd heard that the city of Nantes had some connection with the triangular trade. I went to the city to see what I might find. I walked around the Jardin des Plantes where plant species from around the world were gathered, and along the port to the Jules Verne Museum. I began to notice details here and there, an African head over a doorway, a restaurant called L'Escalve, an Afro-Antilles hairdresser. I began asking local people to tell me what they knew of the city's history. I also mentioned the fabric, which was referred to as *indienne*, and which was produced during the eighteenth century in that region.

In the bedroom of the chateau where I was housed, in the nearby town of Clisson, was a sofa upholstered in a similar fabric. The scene depicted Pocohantas, Columbus, and George Washington in the New World. What was the history of this pervasive fabric, which in the U.S. could symbolize a mark of distinction and in France could represent a prosaic simulation of the past, on which situations open to narration appeared? A fabric you could stare at and make conjectures while falling asleep. A storybook fabric. Or was it more?

Excerpt from *Collecting Well is the Best Revenge* by Renée Green ©1995

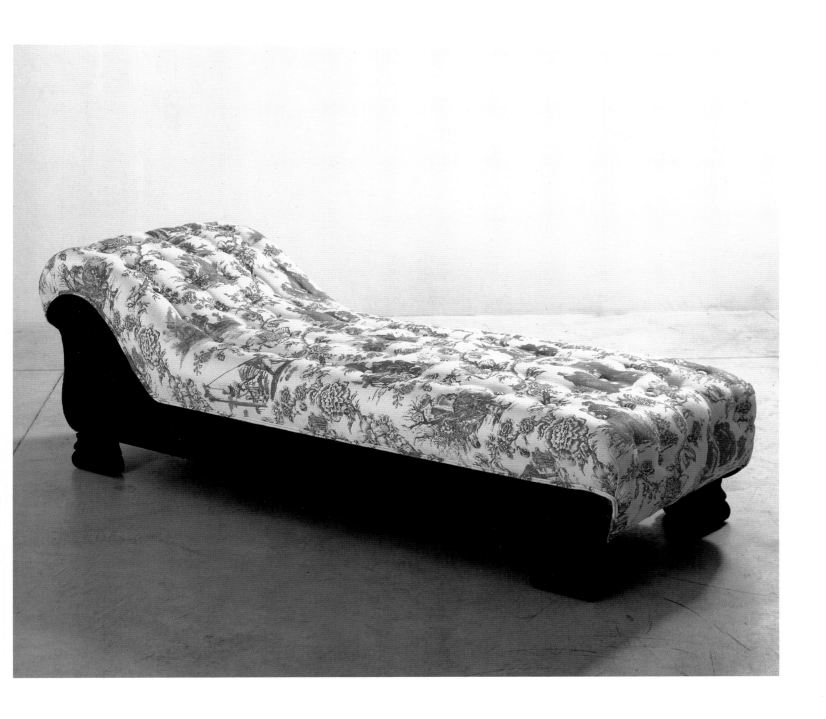

*Commemorative Toile: Chaise*, 1994. Chaise lounge covered in cotton toile, 24 × 28 × 72 inches

## Oliver Herring

Oliver Herring's knitting can be seen as a meditation on the passage of life, its construction and unraveling.

In the very process of knitting, he literally marks time. Each stitch is recorded as a slash in his diary, so that he may adhere to the set pattern. Beyond the initial determination of shape, worked out mathematically, Herring has chosen a medium that requires few artistic choices to be made in the process. Rhythmic and monotonous, the act of knitting sets his mind free at the same time that it occupies his hands and wearies his body.

Herring conceived the knitting in 1991 as a reaction to the suicide of performance artist Ethyl Eichelberger, who was dying of AIDS. The choice of knitting, a traditionally feminine craft, was a deliberate homage to Eichelberger's gender-bending persona. The act of knitting granted time for mourning and healing, and the garments it produced—coats, trousers, sweaters—were elegiac in their emptiness.

The metallic appearance of the silver Mylar suggests a weight and rigidity at odds with the responsiveness of the material; the ability of the transparent Mylar to reflect and conduct light suggests a purity and preciousness generally associated with far less common materials. Its apparent delicacy belies its resilience and speaks to the issue of mortality and the sense of personal vulnerability that has grown in Herring's work.

Janie Walker

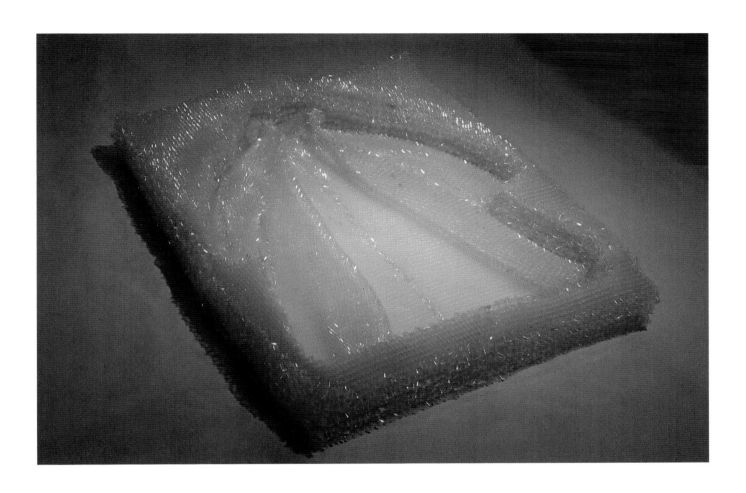

*Castle*, 1994. From the series *A Flower for Ethyl Eichelberger*. Knitted transparent Mylar, 9 × 47 × 65 inches

*Dale Kistemaker*

Much of my childhood was solitary and I was obsessed with making and collecting miniatures and scale models. Every building and component of the village of Plasticville, a town I constructed for my toy railroad, was carefully selected and represented the experiences of my daily life. The surviving structures and my report cards, autograph books, and drawings are clues to my earliest awareness, imagination, education, and expectations of behavior.

*His Bedroom* examines the formation and function of memory through the metaphor of sleep and dreaming. The bedroom is like a camera obscura; the darkened room admits images of the world projected for our inspection.

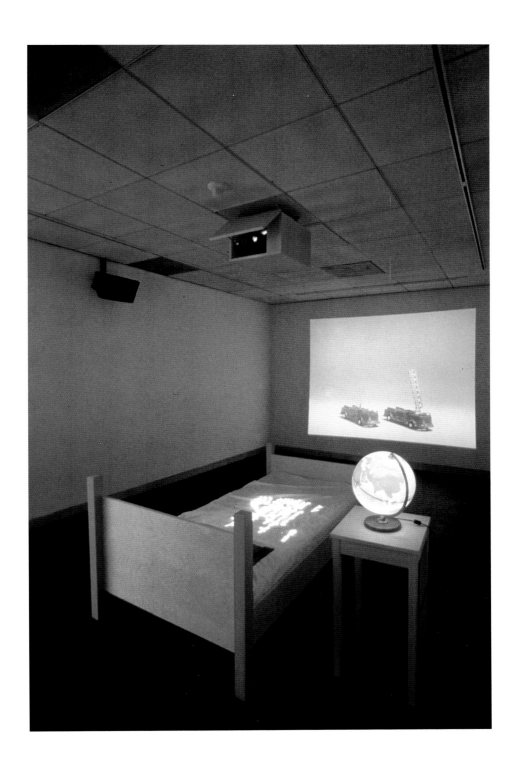

*His Bedroom*, 1994. Mixed media installation, dimensions variable

*Lauren Lesko*

*Coifed* transforms a piece of furniture designed for daydreaming into a seemingly animate piece of dream furniture. This place of repose was used by analysts to encourage therapeutic remembering but can also enable a happy forgetting. On Lauren Lesko's *Coifed* the dreamer is absent while the dream-vehicle idles on its florid pillow. Let's fire the doctor and take a dive into this fur.

David Humphrey

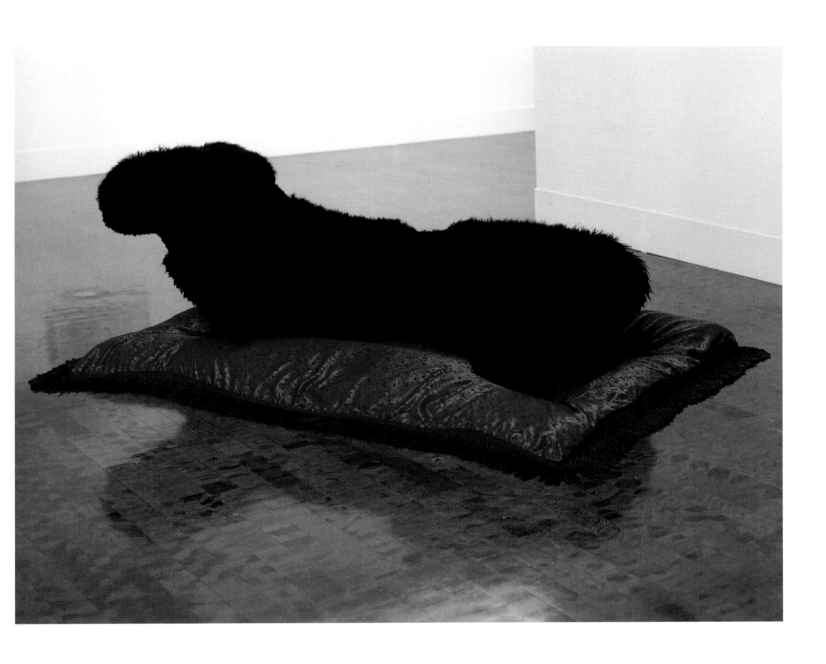

*Coifed*, 1993–94. Couch covered in Mongolian lambskin with silk jacquard and red bouillion duvet cover, couch, 30 × 30 × 76 inches; duvet, 3 × 74 × 96 inches

*Donald Lipski*

In 1990 my cousin had ovarian cancer. I felt she was holding on to life from event to event. She rallied for her daughter's Bat Mitzvah in the Spring. With a fall show scheduled in Chicago, where we had grown up together, and where she still lived, I thought to do something optimistic as a way of making the next event.

I don't set out to make metaphors. I try rather to choose objects and materials which will be suggestive enough, rich enough, for the viewer to make her own metaphors. In this light, I chose to build the exhibition around candles.

My wife and I were trying very hard to conceive at the time. Perhaps that is why this crib got filled with candles, as a sort of prayer.

My cousin has since passed her five year clear date. My son Jackson is now four years old.

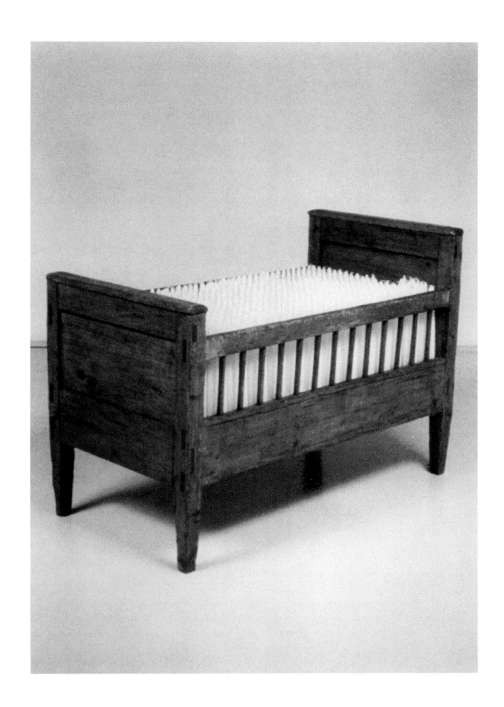

*Untitled #C-03*, 1991. Candles and wooden crib, 29½ × 24 × 44½ inches

*Antonio Martorell*

*Kamikaze* came about by the addition of memories, textures, and transparencies. Sleep as rehearsal of death, the mosquito net as anticipation of the funeral shroud; both as protection from dangerous living things. The bed as playpen, temple, and enlarged garment to cover and reveal the nakedness of the exposed body at rest.

It was during World War II and the blackout warnings that heralded the never-to-come bombardments which were substituted by suicidal insects diving for our blood. Huddled altogether in the loud tropical night, we imagined monsters out of shadows, menacing sounds from the nearby owl, the silken touch of the windblown gauze sending chills up our spine.

Fear and beauty forever united as an intimation of art, a loving, fascinating imitation of life.

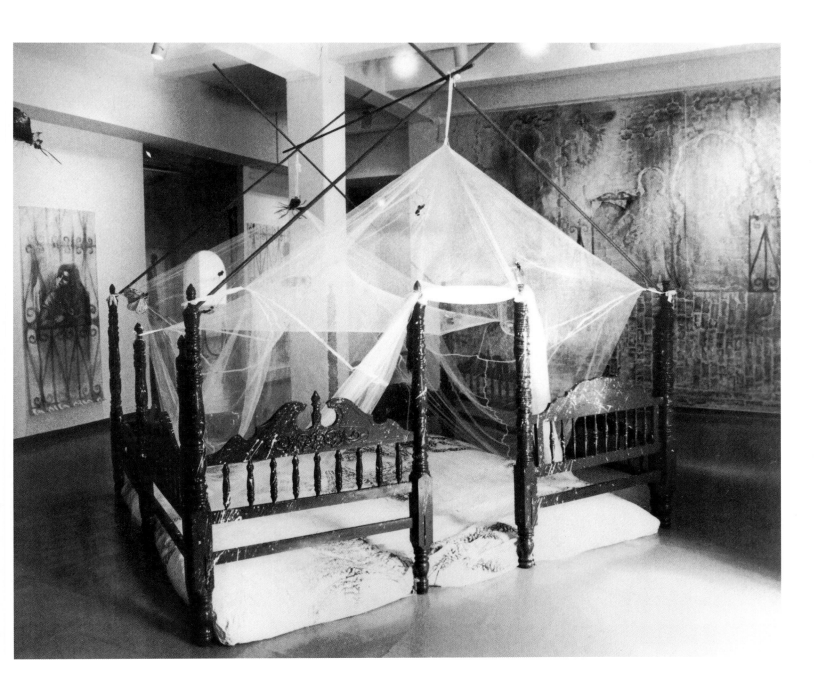

*Kamikaze*, 1991. Installation: wood, fabric, wire, sequins, and foam, c. 108 × 120 × 144 inches

*Ann Messner*

. . . he was, in fact, unconsciously playing an insane game, and the dreams were seeking to bring it to the level of consciousness in a curiously ambiguous way. Hobnobbing with Napoleon and being on speaking terms with Alexander the Great are exactly the kind of fantasies produced by an inferiority complex. But why, one asks, could not the dream be open and direct about it and say what it had to say without ambiguity?

I have frequently been asked this question, and I have asked it myself. I am often surprised at the tantalizing way dreams seem to evade definite information or omit the decisive point. Freud assumed the existence of a special function of the psyche, which he called the "censor." This, he supposed, twisted the dream images and made them unrecognizable or misleading in order to deceive the dreaming consciousness about the real subject of the dream. By concealing the critical thought from the dreamer, the "censor" protected his sleep against the shock of a disagreeable reminiscence. But I am skeptical about the theory that the dream is the guardian of sleep; dreams just as often disturb sleep. . . .

Carl Jung. From "Approaching the Unconscious" in *Man and His Symbols*, 1964

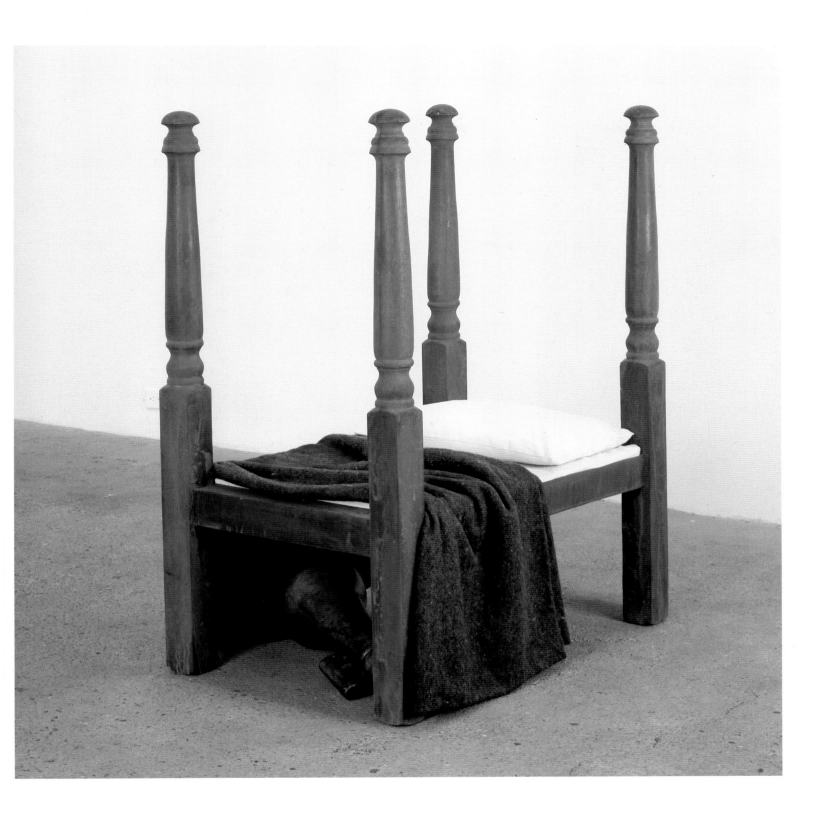

*Bed*, 1993. Cast iron and cloth, 47 × 25 × 37 inches

*Curtis Mitchell*

The expression that there is nothing to express, nothing with which to express, nothing from which to express, no power to express, no desire to express, together with the obligation to express.

Samuel Beckett

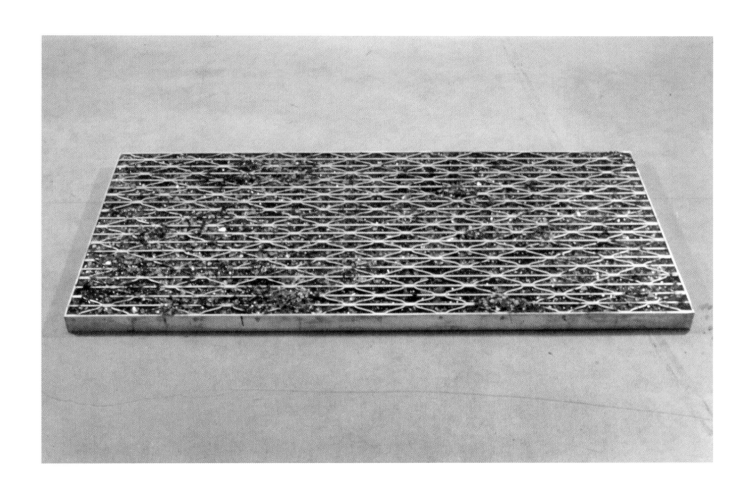

*Untitled (Sidewalk grating)*, 1990. Sidewalk grating, crushed glass, and reconstituted dirt, 3 × 37 × 72 inches

*Lorie Novak*

I am interested in the relationship between photographic imagery and memory, particularly how personal and collective memory affect the reading of photographs. The photographs in this exhibition are from a body of work made between 1979 and 1988 when I created installations by projecting slides of my family's snapshots and historical/cultural imagery on to interior spaces and then photographed them. In using projected imagery, I am intrigued by how the slides create a visual structure. They question what is real as well as supply the emotional, narrative, and cultural content. Empty rooms are filled with "projections" replaying psychological and emotional events. The room becomes a metaphor for the mind. The slides, and props such as beds and chairs, are about presence and absence. When I use a bed, it becomes a stage—the site of dreams, nightmares, and memories.

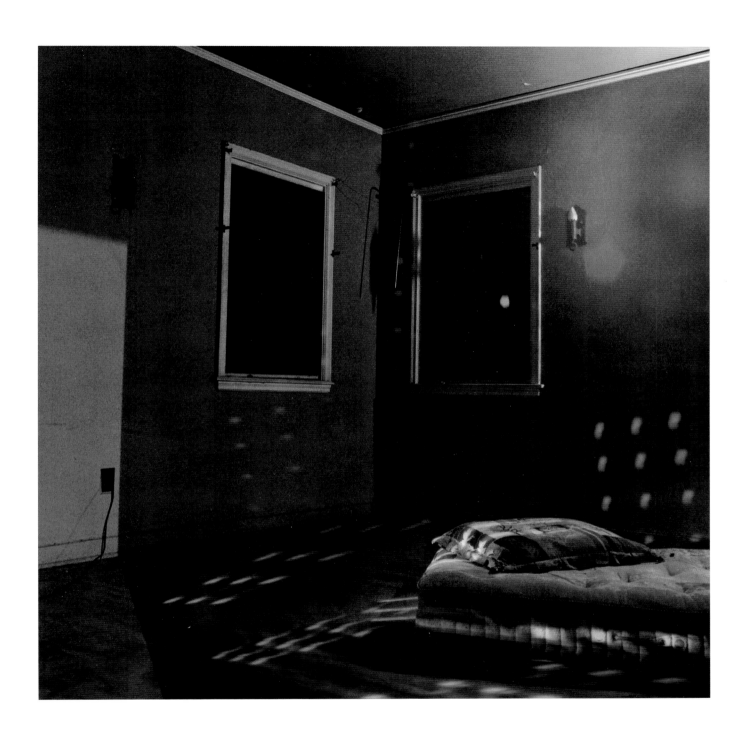

*The Green Room*, 1979. Color photograph, 30 × 30 inches

*Rona Pondick*

NO NO NO NO NO NO NO NO NO NO
NO NO NO NO NO NO NO NO NO NO
NO NO NO NO NO NO NO NO NO NO
NO NO NO NO NO NO NO NO NO NO
NO NO NO NO NO NO NO NO NO NO
NO NO NO NO NO NO NO NO NO NO
NO NO NO NO NO NO NO NO NO NO
NO NO NO NO NO NO NO NO NO NO
NO NO NO NO NO NO NO NO NO NO
NO NO NO NO NO NO NO NO NO NO
NO NO NO NO NO NO NO NO NO NO
NO NO NO NO NO NO NO NO NO NO
NO NO NO NO NO NO NO NO NO NO
NO NO NO NO NO NO NO NO NO NO
NO NO NO NO NO NO NO NO NO NO

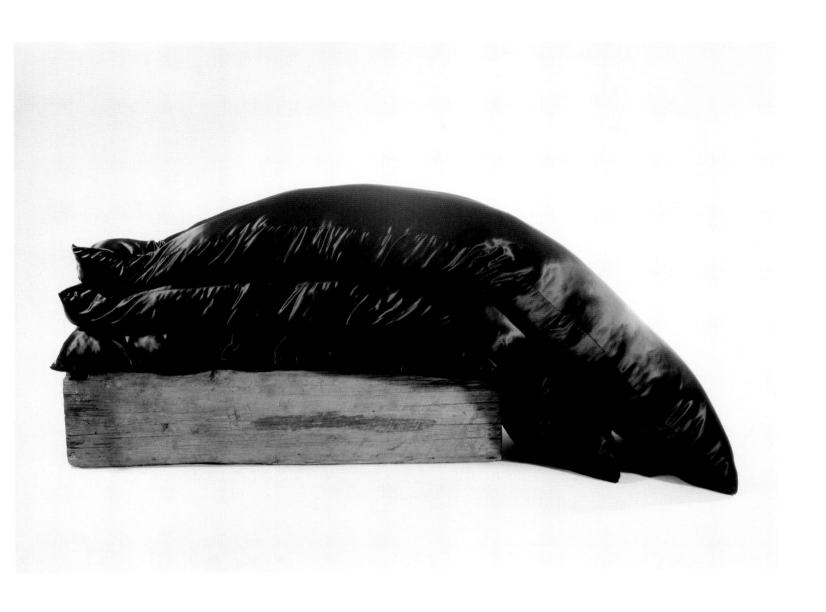

*Black Bed*, 1987. Wood, satin pillows, and bronze, 32 × 24 × 72 inches

*David Reed*

Several years ago, Nicholas Wilder and I were discussing John McLaughlin's paintings. He said that McLaughlin's paintings were "bedroom paintings." "Bedroom paintings," I asked, "what does that mean?" Nick answered that often people would buy a painting by McLaughlin to hang in their living room. After a while, they would move the painting to their bedroom where they could live with it more intimately. I said, "My ambition in life is to be a bedroom painter."

Once someone asked, "What bedroom?" Without thinking, I answered, "The bedrooms in Alfred Hitchcock's *Vertigo*."

I didn't know what I was saying. Scottie's bedroom in *Vertigo* is the site of one of the most perverse love scenes in any movie. Scottie carries "Madeleine" to his bed and undresses her while she (really Judy) pretends to be unconscious. This scene was too sexually provocative for Hitchcock to include; he could only suggest it by showing "Madeleine's" wet clothes hanging out to dry, and by creating the bedroom's shadowy lighting and warm atmosphere. What might a painting have witnessed here?

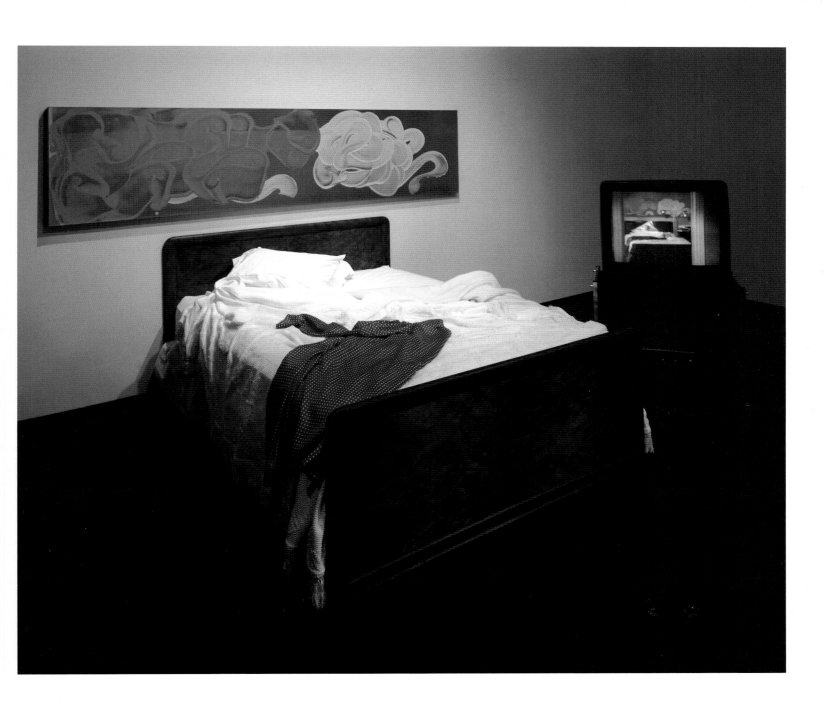

*A Painting in Scottie's Bedroom*, 1995. Mixed media installation, dimensions variable

*Elaine Reichek*

The recreation of my childhood bedroom explores
the idea of decor as a means of Americanizing, of
'passing,' and of connecting people to a past they
wished was their own.

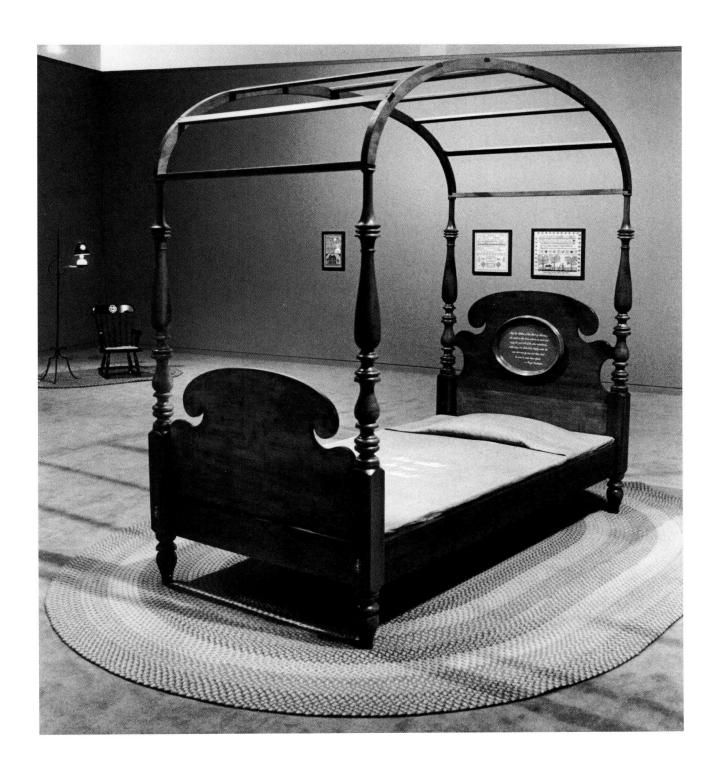

*A Postcolonial Kinderhood*, 1983. Mixed-media installation, bed: 83 × 78 × 40 inches

*Catherine Saalfield*
*and Zoe Leonard*

Seven years have passed since we made *Keep Your Laws Off My Body* and it has only gotten worse out there, in here, around the world. The Theocratic Right sharpened its claws for battle and then declared one loud and clear. We (almost all) find ourselves the brunt of their brutality. They freely display racial fears and sexual insecurities by picking on immigrants, lesbians, gays and bisexuals, people of color, artists, welfare recipients, single moms, single women and every other kind of woman, workers and anyone who's not their kind of "Christian."

Since *Keep Your Laws Off My Body,* 1989, I've made two videotapes about the Religious/Far/Rabid Right and how people have challenged the bigotry— *Sacred Lies Civil Truths,* 1993 and *When Democracy Works,* 1996. Attacks on social, racial, cultural, political, sexual, and economic identities continue to be both figuratively and metaphorically represented by real bodies and physical harm.

Catherine Saalfield

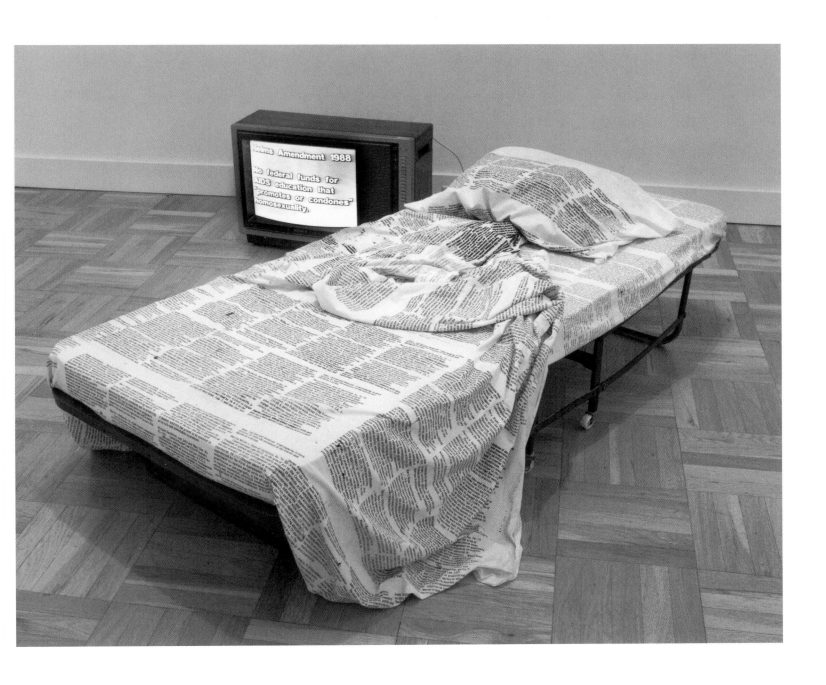

The text on the monitor reads:

Helms Amendment 1988

No federal funds for AIDS education that "promotes or condones" homosexuality.

*Keep Your Laws Off My Body*, 1989. Video installation: bed with silkscreened sheets; monitor; videotape, black-and-white, sound, 13 minutes, dimensions variable

*Jana Sterbak*

NOTICE, Persons attempting to find a motive in this
narrative will be prosecuted; persons attempting to
find a moral in it will be banished; persons attempt-
ing to find a plot in it will be shot.
BY ORDER OF THE AUTHOR.

Mark Twain, from *Huckleberry Finn*

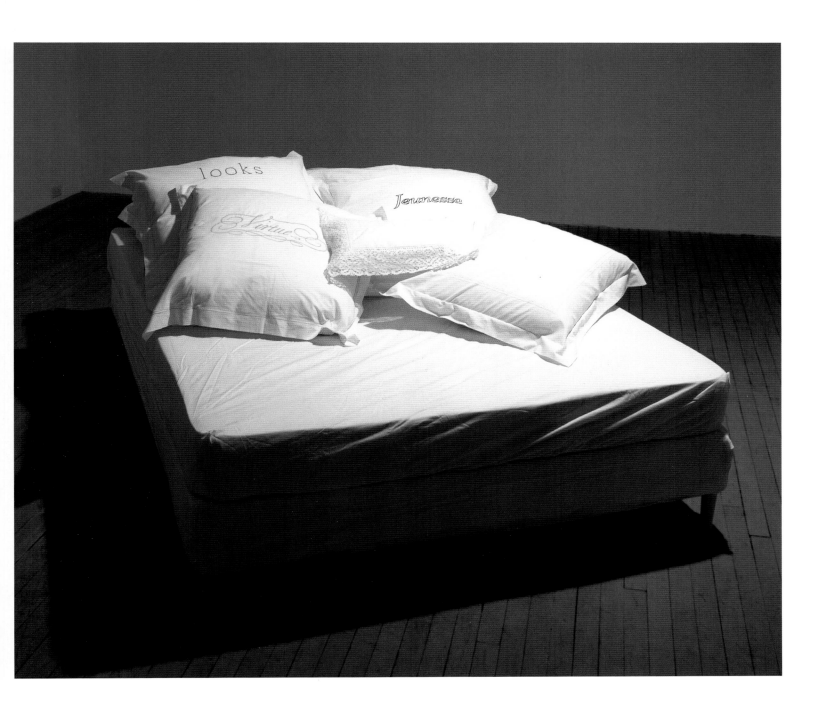

*Attitudes*, 1996. Mixed media installation: bed, 7 embroidered cotton pillowcases, and 2 cotton sheets, overall dimensions variable

*Rirkrit Tiravanija*

"Azure," 1963

We've come to the end of a wet July,

what I need is to discover a mystical

azure, I remember the

blues, I've seen in the Old Masters,

on more than one mantle of the Virgin, and

the distant blue that serves as inalterable sky

for conventional scenes of the Passion.

Those theatrical blues that I

wanted to plumb and of which the true memory,

that of matter

perfectly handled, has stayed

in my mind. Azure, formless

construction site, Golgotha and Tower

of Babel, Matter.

The first stage

of most of my journeys has been the ancient

daydream, an approximation as

close to and far from the *brilliant*

*idea* at its point of departure as during

its flight to its point of arrival,

sleep or rapture, the idea's repose. Image

in pursuit of image, solitude provoked

by a more [profound]* denial.

Marcel Broodthaers, translated by John Shepley

*The word profound is crossed out in the original manuscript

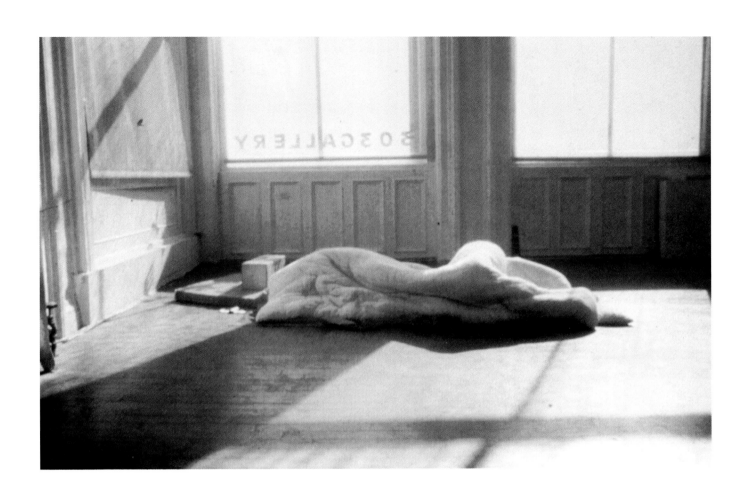

*Untitled (Sleep/Winter)*, 1993. Cotton comforter, foam-filled mattress, straw mat, sheets, and pillow, dimensions variable

*Carrie Mae Weems*

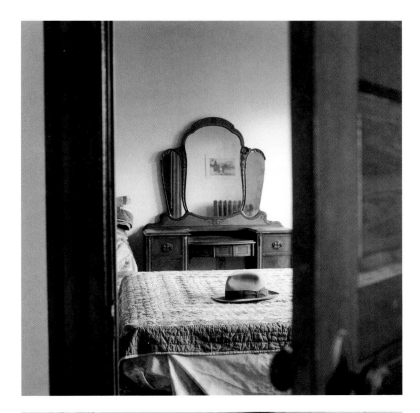

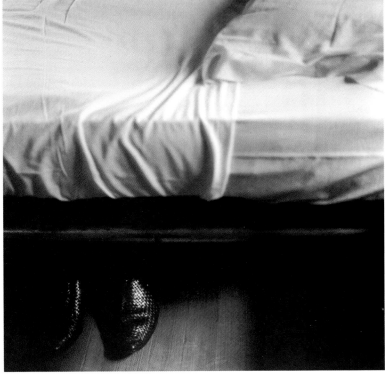

*Sea Islands Series*, 1992. Gelatin silver print diptych, 40 × 20 inches overall

*Ton Zwerver*

The *Sculptures for the Moment* are defined in large part by the place where they are created; they react to the space, the light, and the atmosphere of a specific location and time.

I build the *Sculptures for the Moment* in office spaces, factories and other places that are abandoned. I make the sculptures from objects that are present at the locations. I use the objects to leave my own traces.

My sculptures are a form of description, memory, feeling, and thoughts that move constantly back and forth, from trivial to important and back to the trivial again.

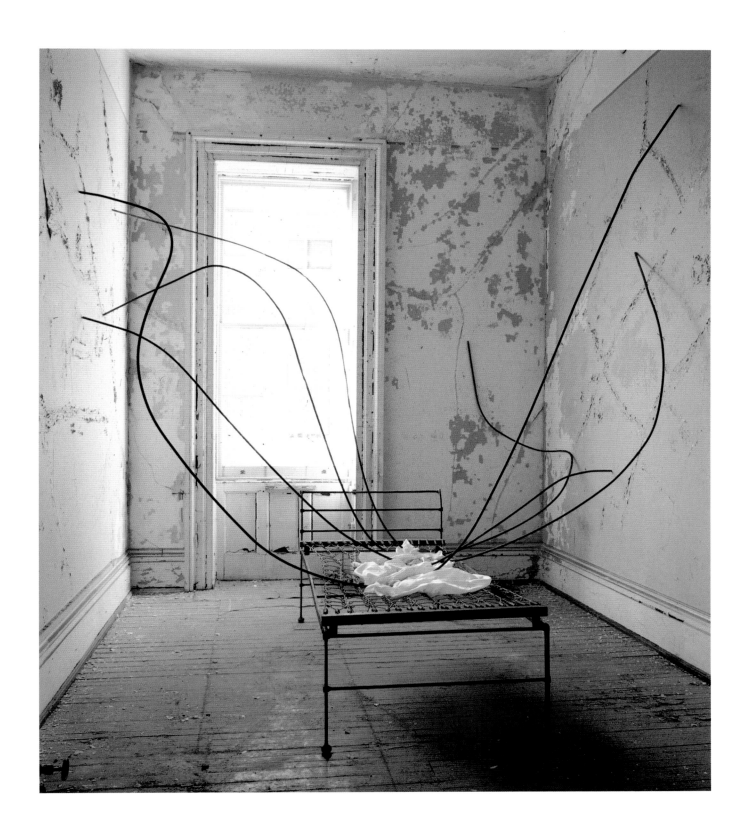

*15-10-1995 Sculpture for the Moment, Snug Harbor, New York, USA, 1995.* Cibachrome print, 35 × 20 inches

# Checklist

Height precedes width precedes depth. Unless otherwise noted, all dimensions are unframed.

## Perry Bard

Born: Quebec City, Quebec, Canada
Resides: New York, New York

*Shelter, 111 Centre Street, New York City*, November 1989
Cibachrome print
16 × 20 inches
Courtesy the artist

*Shelter, 111 Centre Street, New York City*, November 1989
Cibachrome print
16 × 20 inches
Courtesy the artist

*Shelter, 111 Centre Street, New York City*, November 1989
Cibachrome print
16 × 20 inches
Courtesy the artist

*Shelter, Lafayette at White, New York City*, 1990
Cibachrome print
16 × 20 inches
Courtesy the artist

*Shelter, Lafayette at Franklin, New York City*, 1992
Cibachrome print
16 × 20 inches
Courtesy the artist

*Shelter, 6th Avenue at Houston, New York City*, 1992
Cibachrome print
16 × 20 inches
Courtesy the artist

*Shelter, Broadway at Leonard, New York City*, 1994
Cibachrome print
16 × 20 inches
Courtesy the artist

*Shelter, Spring between Greenwich and Washington, New York City*, 1995
Cibachrome print
16 × 20 inches
Courtesy the artist

## Janet Biggs

Born: 1959, Harrisburg, Pennsylvania
Resides: New York, New York

*Crib*, 1993
Installation: wood, cotton, and stuffed toys
76h × 132 inches in diameter
Courtesy the artist

## James Casebere

Born: 1953, Lansing, Michigan
Resides: New York, New York

*Bed Upturning Its Belly*, 1976
Gelatin silver print
16 × 20 inches
Courtesy the artist

*Asylum*, 1994–95
Cibachrome print
60 × 48 inches
Courtesy the artist

*A Barrel Vaulted Room*, 1994–95
Cibachrome print
60 × 48 inches
Courtesy the artist

## Mel Chin

Born: 1951, Houston, Texas
Resides: New York, New York

*Jilava Prison Bed*, 1982
Steel and cotton
Irregular, approximately 42 × 37 × 69 inches
Courtesy George Adams Gallery, New York

## Lynne Cohen

Born: 1944, Racine, Wisconsin
Resides: Ottawa, Ontario, Canada

*Showroom*, n.d.
Gelatin silver print with text on mat
43¾ × 50½ inches (framed)
Courtesy the artist and P·P·O·W, New York

*Classroom*, n.d.
Gelatin silver print with text on mat
43¾ × 50½ inches (framed)
Courtesy the artist and P·P·O·W, New York

## Caryl Davis

Born: Schenectady, New York
Resides: Venice, California

*Conspire*, 1990
Bed, linens, pillows, and prayer benches
56 × 44 × 74 inches overall
Courtesy the artist

## Bob Flanagan and Sheree Rose

Bob Flanagan
Born: 1952, New York, New York
Died: 1996

Sheree Rose
Born: 1952, Los Angeles, California
Resides: Los Angeles, California

*Gurney of Nails*, 1992
From *Visiting Hours*
Hospital gurney and 1,400 nails
37 × 27 × 71 inches
Courtesy the artists

## Renée Green

Born: 1959, Cleveland, Ohio
Resides: Brooklyn, New York

*Commemorative Toile: Chaise*, 1994
Chaise lounge covered in cotton toile
24 × 28 × 72 inches
Courtesy Pat Hearn Gallery, New York

## Oliver Herring

Born: 1964, Heidelberg, Germany
Resides: Brooklyn, New York

*Castle*, 1994
From the series *A Flower for Ethyl Eichelberger*
Knitted transparent Mylar
9 × 47 × 65 inches
Courtesy the artist and
Max Protetch Gallery, New York

## Dale Kistemaker

Born: 1948, Cleveland, Ohio
Resides: San Francisco, California

*His Bedroom*, 1994
Mixed media installation
Dimensions variable
Courtesy the artist

## Lauren Lesko

Born: 1952, Los Angeles, California
Resides: New York, New York

*Coifed*, 1993–94
Couch covered in Mongolian lambskin with
silk jacquard and red bouillion duvet cover
Couch, 30 × 30 × 76 inches
Duvet, 3 × 74 × 96 inches
Courtesy Robert J. Shiffler Collection, Greenville, Ohio

## Donald Lipski

Born: 1947, Chicago, Illinois
Resides: Brooklyn, New York

*Untitled #C-03*, 1991
Candles and wooden bed
29½ × 24 × 44½ inches
Courtesy the artist and Galerie Lelong, Paris

## Antonio Martorell

Born: 1939, Puerto Rico
Resides: Cayey, Puerto Rico

*Kamikaze*, 1991
Installation: wood, fabric, wire, sequins, and foam
108 × 120 × 144 inches
Courtesy the artist

## Ann Messner

Born: 1952, New York, New York
Resides: New York, New York

*Bed*, 1993
Cast iron and cloth
47 × 25 × 37 inches
Courtesy Bill Maynes Contemporary Art, New York

## Curtis Mitchell

Born: 1954, New York, New York
Resides: New York, New York

*Untitled (Sidewalk grating)*, 1990
Sidewalk grating, crushed glass, and
reconstituted dirt
3 × 37 × 72 inches
Courtesy the artist

## Lorie Novak

Born: 1954, Los Angeles, California
Resides: Brooklyn, New York

*The Green Room*, 1979
Color photograph
30 × 30 inches
Courtesy the artist

*Mirror Image*, 1983
Color photograph
30 × 30 inches
Courtesy the artist

## Rona Pondick

Born: 1952, Brooklyn, New York
Resides: New York, New York

*Black Bed*, 1987
Wood, satin pillows, and bronze
32 × 24 × 72 inches
Courtesy Sidney Janis Gallery, New York

## David Reed

Born: 1946, San Diego, California
Resides: New York, New York

*A Painting in Scottie's Bedroom*, 1995
Mixed media installation
Dimensions variable
Courtesy the artist and
Max Protetch Gallery, New York

## Elaine Reichek

Born: New York, New York
Resides: New York, New York

*A Postcolonial Kinderhood*, 1994
Mixed-media installation
Bed, 83 × 78 × 40 inches
Courtesy Michael Klein Gallery, New York

## Catherine Saalfield and Zoe Leonard

Catherine Saalfield
Born: 1965, New York, New York
Resides: New York, New York

Zoe Leonard
Born: 1962, New York, New York
Resides: New York, New York

*Keep Your Laws Off My Body*, 1989
Video installation: bed with silkscreened sheets;
monitor; videotape, black-and-white, sound,
13 minutes
Dimensions variable
Courtesy the artists

## Jana Sterbak

Born: 1955, Prague, Czechoslovakia
Resides: Montreal, Canada and Paris, France

*Attitudes*, 1987
Mixed media installation: bed, 7 embroidered
cotton pillowcases, and 2 cotton sheets
Courtesy the Mackenzie Art Gallery, University
of Regina Collection

Sheets, 109 1/16 × 101 15/16 inches each

Pillowcases:

*Reputation*
27 9/16 × 28 3/4 × 7 7/8 inches

*Looks*
29 9/16 × 28 3/8 × 7 7/8 inches

*Virtue*
28 3/8 × 27 15/16 × 9 1/8 inches

*Jeunesse*
28 3/8 × 28 3/8 × 7 7/8 inches

*Sexual Fantasies*
20 7/8 × 29 9/16 × 7 7/8 inches

*Avarice*
23 5/8 × 28 3/4 × 7 7/8 inches

*Disease*
17 3/4 × 14 3/16 × 6 5/16 inches

## Rirkrit Tiravanija

Born: 1961, Buenos Aires, Argentina
Resides: New York, New York

*Untitled (Sleep/Winter)*, 1993
Cotton comforter, foam mattress, straw mat,
sheets, and pillow
Dimensions variable
Courtesy Gavin Brown Enterprises, New York

## Carrie Mae Weems

Born: 1953, Portland, Oregon
Resides: Syracuse, New York

*Sea Island Series*, 1992
Gelatin silver prints
Diptych, 40 × 20 inches overall
Courtesy the artist and P·P·O·W, New York

## Ton Zwerver

Born: 1945, Amsterdam, The Netherlands
Resides: Amsterdam, The Netherlands

*15-10-1995 Sculpture for the Moment,*
*Snug Harbor, NY, USA*, 1995
Cibachrome print
35 × 20 inches
Collection Michael and Barbara Smith

*Reproduction Credits*

In addition to all other copyrights and reservations pertaining to works published in this catalogue and held by living artists, their estates, publications, and/or foundations, and in addition to the photographers and the sources of photographic material other than those indicated in the captions, the following are mentioned:

Dennis Cowley 58
Courtesy El Museo del Barrio, New York 49
Courtesy René Blouin Gallery, Montreal 65
Courtesy Renée Green with the Fabric
    Workshop and Museum 39
Courtesy T'ZArt, New York 71
Courtesy The New Museum of Contemporary
    Art, New York, installation September 23–
    December 31, 1994 37
Courtesy The Portland Art Museum,
    Portland, Oregon 63
Courtesy the Wexner Center for the Arts,
    The Ohio State University, Columbus, Ohio 61
D. James Dee 14
Frank Gimpaya 48
David Heald © The Solomon R. Guggenheim
    Foundation, New York. 9
Erik Landsberg 38
Peter Muscato 11, 18
David Potter 62
Oren Slor 50

© 1996 Independent Curators Incorporated
799 Broadway, Suite 205
New York, New York 10003
212-254-8200;        fax: 212-477-4781
e-mail: ici@inch.com

Editorial consultant: Maria-Christina Villa Señor
Design and typography: Russell Hassell
Lithography: The Studley Press
Edition of 2,000

Library of Congress Catalogue Card Number: 96-77165
ISBN: 0-916365-48-4